# POCKET GUIDES
# NARRATIVE

## Erika Langmuir

NATIONAL GALLERY COMPANY LONDON

DISTRIBUTED BY YALE UNIVERSITY PRESS

Front cover and title page:
Luca Giordano, *Perseus turning Phineas and his Followers to Stone*,
early 1680s, detail.
Page 4: Domenico Beccafumi, *The Story of Papirius*,
probably 1540–50, detail.

© National Gallery Company 2003

All rights reserved. No part of this publication may be transmitted in
any form or by any means, electronic or mechanical, including
photocopy, recording, or any storage and retrieval system, without the
prior permission in writing from the Publisher.

First published in Great Britain in 2003 by
National Gallery Company Limited
St Vincent House, 30 Orange Street, London WC2H 7HH
www.nationalgallery.co.uk

ISBN 1 85709 257 0

525239

British Library Cataloguing-in-Publication data.
A catalogue record is available from the British Library.
Library of Congress Catalog Card Number: 2002110963

Edited by Jane Ace
Designed by Gillian Greenwood
Production by Jane Hyne
Printed and bound in China

# CONTENTS

FREE PUBLIC LIBRARY
NEW HAVEN, CT. 06510

# FOREWORD

The National Gallery contains one of the great collections of European paintings in the world. Open daily and free of charge, it is visited each year by up to five million people.

We hang the collection by date, to allow those visitors an experience that is virtually unique: they can walk through the story of Western painting as it developed across the whole of Europe from the beginning of the Renaissance to the end of the nineteenth century – from Giotto to Cézanne.

But if that is a story only the National Gallery can tell completely effectively, it is by no means the only story. The purpose of this series of *Pocket Guides* is to explore some of the others – to re-hang the collection according to subject, rather than date, and to allow you to take it home in a number of different shapes, and to follow different themes.

However, as Erika Langmuir discusses in this guide, the stories that come to mind in front of the pictures are not always those the artists meant to tell. In this *Pocket Guide* the author introduces some of the most intriguing examples of Western narrative painting to a modern audience and examines the different styles of narrative painting whilst analysing the evolution of the genre.

These are the kind of subjects that the *Pocket Guides* address. The pleasures of pictures are inexhaustible, and our hope is that these little books point their readers towards new ones, prompt them to come to the Gallery again and again and accompany them on further voyages of discovery.

*Charles Saumarez Smith*
DIRECTOR

# INTRODUCTION

*Every picture tells a story?*

As any eavesdropper in a gallery knows, it's not pictures that tell stories but people: every picture evokes as many stories as it has spectators. Yet the stories we hear in front of pictures are not necessarily those the artists meant to tell.

Take, for example, this scene painted around 1500 by the Florentine eccentric Piero di Cosimo [1]. It may remind us of last year's office party, or a picnic that went wrong, but we know Piero did not intend to stimulate our imagination in this random way (now as we shall see, pages 76–9, artists are less bossy).

1. Detail of 2.

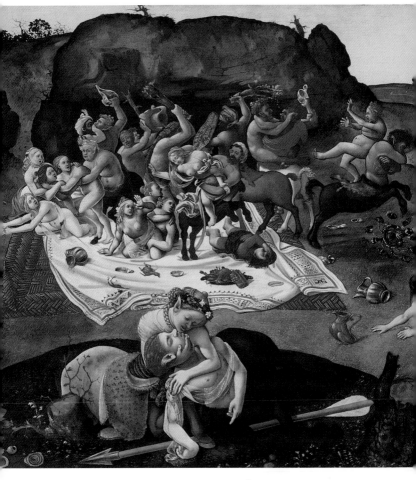

After searching the painting and their memory for clues, most visitors to the National Gallery will turn for guidance to the written label on the wall near the picture:

> Piero di Cosimo (about 1462–after 1515),
> *The Fight between the Lapiths and the Centaurs,*
> probably 1500–15.
> *This subject is from a classical text, Ovid's* Metamorphoses. *It shows drunken centaurs disrupting the wedding feast of the King of the Lapiths. It was probably part of a chest in a Florentine palace. Such furniture was often ordered to celebrate a marriage. The subject would have been regarded as entertaining for such a purpose.*

This text points us in the right direction. Ovid was a first-century Latin poet, whose *Metamorphoses* recounted pagan Greek myths of miraculous transformations; centaurs are a mythical species, half-human, half-horse, supposedly related to the King of the Lapiths, an actual tribe of ancient Greeks.

To see what centaurs look like we must return to the picture. And to see how Piero 'imagined' the entire story – how he translated Ovid's words into images – we must compare the whole painting with the poet's own text in Book XII of *Metamorphoses* [2].

In the poem, the wedding feast was held at tables 'set in order in a tree-sheltered cave' that served as the great hall of the royal palace. By laying a cloth on a rush mat on the ground outside the cave, Piero may be suggesting that the Lapiths, though owning tableware, were too 'primitive' to eat at tables. He certainly pictures them as no less savage than their beastly guests [3]. More significantly, he changes the emphasis of Ovid's story. The key episode of the myth recounts how the fight began when 'the fiercest of all

2. Piero di Cosimo, *The Fight between the Lapiths and the Centaurs,* probably 1500–15. 71 × 260 cm.

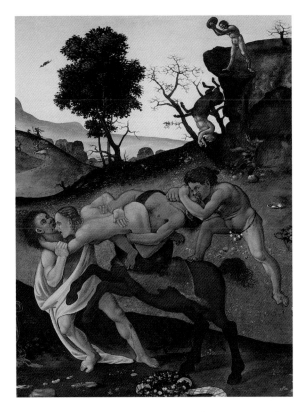

3. Detail of 2.

the fierce centaurs', in a drunken frenzy 'intensified by lust', dragged the new bride 'off by the hair'. Bride and centaur appear in the *mêlée* to the right of the picture [4], but the painter directs, or misdirects, our attention to another couple, whom he isolates centre stage. They are minor characters in Ovid's text: a beautiful centaur ('if indeed we allow beauty to such a shape as his'), innocently caught up in the battle and fatally wounded by a Lapith javelin, and his devoted wife, the 'comeliest of all the female centaurs', who will kill herself out of grief for him. It is these blameless and tender, but only part-human, lovers who are the protagonists of the painter's tale – and the only characters who arouse our sympathy.

*The Fight of the Lapiths and Centaurs* had always been understood as a parable of civilisation battling barbarism personified by the centaurs, whose animal instincts prevailed over reason and good manners. The picture subverts this conventional reading. It does not surprise us to learn that Piero di Cosimo loved animals more than people, and – not permitting

8

his vines and fruit trees to be pruned – he was 'content to see everything run wild, like his own nature'.

The exchange between painters of stories and viewers is most fruitful when they share similar expectations, a common frame of reference.

Piero's contemporaries, viewing *The Fight Between the Lapiths and the Centaurs* in a stylish domestic interior in Florence, were better equipped to appreciate the picture than viewers are today. They could enjoy the artist's careful yet irreverent reading of a literary classic, for some learnt Ovid at school, and most knew the stories in translation. They could thrill unashamedly at the novel show of nakedness and violence, because they understood that this was a cautionary image of the threat posed by drink and

4. Detail of 2.

lust to marital happiness – of Florentine patricians as of Lapiths and centaurs. Able to gauge the influence of ancient sculpture and the latest artistic fashions on the painter, they could also tell when Piero's bizarre pictorial fancies were his own inventions.

Communication between painters and viewers became more difficult when pictures began to be shown out of their original context, in galleries and museums; when viewers became less familiar with the literature and artistic conventions of the past; and when painters started to draw on more wide-ranging and obscure sources.

My aim in this *Pocket Guide* is to smooth away such difficulties by familiarising modern viewers with some of the best, or most intriguing, examples of Western narrative painting. I also hope to show how narrative pictures evolved, how they differ from others that only seem to convey stories – and how viewers' irrepressible tendency to make up stories eventually helped to erode that difference.

5. Paul Delaroche, *The Execution of Lady Jane Grey*, 1833. 246 × 297 cm.

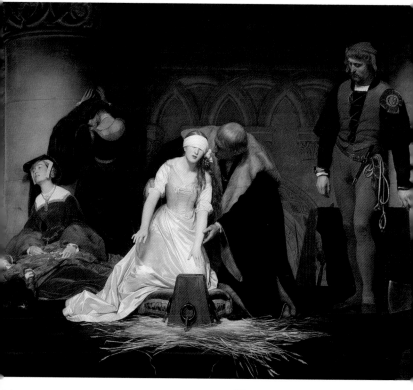

# DEFINING
# NARRATIVE PAINTING

Thomas Mann observes in his novel *The Magic Mountain*, 'Time is the principal element of narrative, as it is the principal element of life'. Like life itself, narrative has a beginning, middle and an end – in whatever order these may be presented in the arts. But it is more than an account of the passage of time. Although it may have universal significance and appeal, a narrative relates a sequence of particular events unfolding through a given period of time, and involving real or fictional individuals.

Stories may be told about animals, or even inanimate objects, but most Western narrative art depicts the vicissitudes of individuals in human form: men, women, children and the gods who take on their semblance.

Perhaps the best-loved narrative painting in the National Gallery, Paul Delaroche's *Execution of Lady Jane Grey* [5], reconstructs, in the idiom of popular melodrama, the last moments in the life of the seventeen-year-old Jane Grey, great-granddaughter of Henry VII, who reigned for nine days in 1553. Deposed by supporters of the Catholic Queen Mary, she was executed for high treason in the Tower of London on 12 February 1554. By making us feel sorry for the frail girl in white, the French artist solicits our sympathy for all victims of unjust persecution. Since he could not rely on viewers recognising this episode from English history, he carefully spelled out the facts in the catalogue of the Paris Salon of 1834, where the picture was first exhibited. He also specified that his inspiration was a book about Protestant martyrs published in 1588.

Less clamorous and popular, a very different picture by Delaroche's compatriot and contemporary, the far greater artist Eugène Delacroix [6], depicts the plight of the artist suffering from the ignorance and ingratitude of his countrymen, as Delacroix felt himself to be. Few viewers at the Salon of 1859 could have identified the story without the help of the catalogue entry:

6. Ferdinand-Victor-Eugène Delacroix, *Ovid among the Scythians*, 1859. 87.6 × 130.2 cm.

*Ovid in exile among the Scythians. Some of them examine him with curiosity. Others welcome him in their own manner, offering wild fruit and mare's milk.*

7. Detail of 6.

In AD 8 the Emperor Augustus, for reasons unknown, banished Ovid from Rome to Tomis, a port on the Black Sea. The Romans believed that the barbarian natives of this region, the Scythians, fed on mare's milk. Delacroix, who loved horses, shows a mare being milked in the foreground. The hapless Ovid is the dreamily reclining figure in Roman dress in the middleground of the picture, unheeding of his rustic hosts' attention as he writes on a scroll [7].

Both Delaroche's and Delacroix's pictures were based on historic events. Until the eighteenth century, however, the majority of narrative paintings were not inspired by history but by classical literature, the Bible and legends of saints' lives, or by more recent epic poetry on chivalric themes.

Any of these subjects could be represented in History Painting, for the term is merely a mistranslation into English – via French – of the old Italian word *istoria*, 'story'. During the Renaissance, *istoria* came to mean a grand, uplifting kind of narrative painting, based on either fact or fiction (see pages 51–68). In time, however, the mistranslation sowed confusion among French and English artists and viewers, who came mistakenly to believe (as many people still do) that History Painting only refers to the painting of history.

Since narrative images present themselves 'all at once' – unlike spoken or written tales that unfold gradually over time – artists evolved various ingenious methods of guiding spectators' engagement with the story. Art historians group these modes of pictorial narration under three main headings (although not all agree on how to name them); in practice, painters have often felt free to combine different narrative methods within a single work.

Piero di Cosimo's picture shows several episodes of one story within one pictorial space, enacted mainly by different figures, but with some subsidiary personages repeated more than once – a convention usually called 'continuous narrative' (see pages 37–45 for more typical examples).

A few, mainly mural artists and printmakers, 'serialised' the story in separate images (see pages 69–72). This method is sometimes termed 'cyclical';

stories painted across several walls are often called 'narrative cycles'. (This use of the term should not, however, be confused with the 'cyclical' imagery of, for example, the recurrent seasons of the year, pages 23–5).

Delaroche and Delacroix focused on one 'telling moment', witnessed from a single point of view. Although this narrative method is sometimes called 'instantaneous', the significant pictorial 'moment' can be of variable duration. Jane Grey's execution did not last as long as Ovid's exile, and the pictures themselves reflect this – Delacroix's spacious and freely brushed landscape discloses its human-interest tale more slowly than Delaroche's spot-lit stage set. Other artists, such as Rubens (pages 33–6), evoked the passage of time by supplementing the principal 'moment' with less conspicuous details from earlier or later parts of the story.

8. Francesco Solimena, *Dido receiving Aeneas and Cupid disguised as Ascanius*, probably 1720s. 207.2 × 310.2 cm.

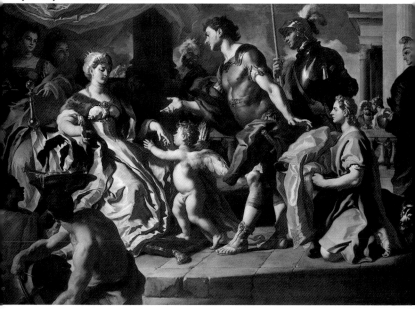

# TWO PAINTINGS
# ONE STORY

How pictures look – their purely visual character – affects not only our reading of the passage of time but our responses more generally. We can see this even more clearly when we compare two different paintings based on the same story.

Figure 8 reproduces a work by Francesco Solimena, painted in the 1720s. Solimena, the leading artist in Naples at that time, was an exuberant decorator of churches and palaces. The owners of these palaces wished to assert their status as cultivated people; some even liked to claim descent from the noble heroes, mythical or historic, of Graeco-Roman antiquity. They therefore favoured subjects from ancient literature – and especially from the best-known works of the greatest Latin poets, Ovid's *Metamorphoses* and Virgil's *Aeneid*.

Solimena's canvas represents a fateful episode from Book I of the *Aeneid*: the beginning of the ill-starred romance between the Trojan Prince Aeneas and Dido, the widowed Queen of Carthage. Fleeing from the sack of Troy, Aeneas and his companions were shipwrecked on the shore of northern Africa. Welcomed by Dido, protégée of the goddess Juno, Aeneas sent his faithful friend Achates back to their ships to fetch his son Ascanius and gifts for the Queen 'snatched from the wreck' of Troy. But Aeneas' mother, Venus, goddess of love and Juno's rival, feared that Dido would turn against the Trojans. Lulling the boy Ascanius to sleep, she despatched her own son Cupid in his stead to make Dido fall in love with Aeneas.

Even stagier and more fantastically costumed than Delaroche's *Execution of Lady Jane Grey* [5], the picture suggests to the modern eye a snapshot of a theatrical performance. The torso-hugging, leotard-like costume of the leading actor – a fancy-dress version of an ancient Roman cuirass – identifies him as Virgil's hero, just as her coronet and exotic turban identify the Carthaginian Queen. The sceptre, necklaces and crown proffered by a black African on the picture's left [9], and the gold cloth held out by the

9. Detail of 8.

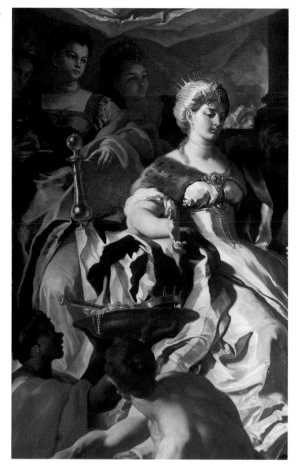

youthful Achates kneeling to the right [10], are the precious gifts specified by Virgil.

Aeneas is preceded by a figure well known to us from Valentine's Day cards: a chubby Cupid with a quiver of feathered arrows. Trailing a red cloak, the winged child bounds onto the cushion at Dido's feet, gallantly raising her hand to his lips.

As in Virgil's text, the characters in the painting do not recognise Cupid impersonating Ascanius. But just as the poet tells readers of the substitution, so the painter lets viewers in on the secret. The visible presence of Cupid is the most important clue to the story.

In other respects, Solimena is not so faithful to the poem. Virgil's Cupid/Ascanius carries the royal gifts into a banqueting hall, where Dido and her guests

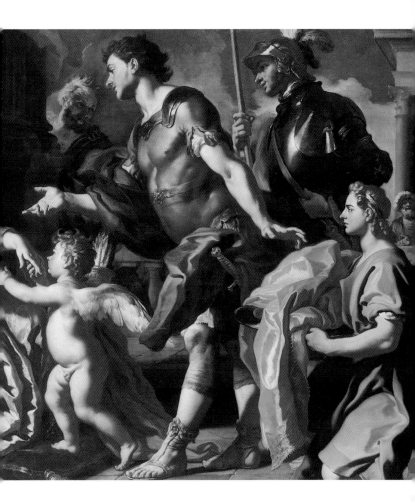

recline on embroidered couches, as fifty maidservants set out the feast. Admittedly, Solimena might have altered the setting for the sake of pictorial clarity – but he may have had other reasons as well.

Virgil's Aeneas was destined by Jupiter, King of the gods, to reach Italy and found the imperial city of Rome. When recalled to his duty by Jupiter's messenger Mercury, he reluctantly abandoned Dido. Seeing her lover's ships sailing away, the forsaken Queen built a funeral pyre, on which she killed herself with the sword Aeneas left behind – presumably the very sword he wears in Solimena's painting.

By the time this picture was painted, the tragic story of Dido and Aeneas was well known and often illustrated as an independent tale. In 1689 it became the subject of the earliest English opera, Henry

Purcell's *Dido and Aeneas*. In 1723 the much-admired Neapolitan poet Metastasio used it for *Dido Abandoned* – a lyrical tragedy in three acts designed to be set to music, and first performed in 1724.

Might Solimena's stagey painting perhaps reflect that performance? Was the artist representing a moment from Virgil's *Aeneid*, the martial account of 'Arms and the man', or the overture to an ill-fated romance – the kind of story later alluded to in Byron's *Don Juan*, 'Man's love is of man's life a thing apart, Tis woman's whole existence'?

As we view the picture, should we be hearing Virgil's majestic verse, or heartbreaking operatic arias?

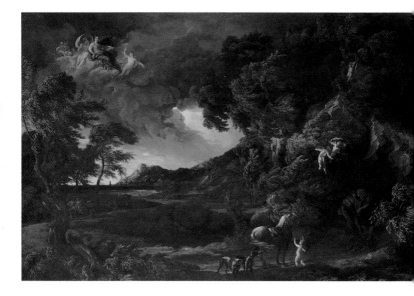

11. Gaspard Dughet and Carlo Maratta, *Landscape with the Union of Dido and Aeneas*, about 1664–8. 152.9 × 223.7 cm.

Look now at this work of the mid-1660s by Gaspard Dughet, to which Carlo Maratta contributed the figures [11].

What we first see is a landscape painting; Dughet was indeed a famous landscape specialist. On closer examination, however, we find another part of the story of Dido and Aeneas.

In Book IV of the *Aeneid* Virgil describes how, despite the queen's vow to remain faithful to her dead husband, she and the Trojan prince were 'linked in sure wedlock'. Through the machinations of Juno – who opposed Jupiter's plans for the foundation of Rome – and with the consent of Venus, a storm broke

out while Dido and Aeneas were hunting among 'the mountain heights and pathless lairs'. Separated from their companions, they found shelter in a cave [12]:

> On that day were sown the seeds of suffering and death. Henceforth Dido cared no more for appearances or her good name, and ceased to take any thought for secrecy in her love. She called it a marriage, and used this word to screen her sin. (Aeneid, IV, 169–172)

Solimena disposed his principal actors across a shallow stage, setting the spectator in a privileged position in the front stalls. The landscapist Dughet

12. Detail of 11.

pictures space as deep as it is broad, setting the viewer at some considerable distance from the foreground. Here, one of Venus' *amoretti* holds a horse's reins and hunting dogs wait restlessly. Still further away, more *amoretti* flutter about the entrance to the cave, seeking to inflame the passions of a barely visible Dido and Aeneas. These are all only small incidents in the vast expanse of rocks, wind-tossed trees (one on the left lies uprooted), storm clouds and rain. At the heart of the storm sit Venus and Juno, despatching Hymen, the Roman god of marriage, down to earth with his fiery torch [13]. 13. Detail of 11.

As in Delacroix's *Ovid among the Scythians* [6], the distances through which our eyes must wander to find the figures serve to emphasise the length of time in which the story unfolds. The picture presents a narrative sequence of cause and effect: the goddesses' pact, the storm, the beginning of the seduction in the cave. An informed viewer can predict the consequences.

Yet if pictorial space evokes narrative time, in this case it also suggests another story, at once more subjective and more universal. Even today, in the mountain ranges south of Rome which were Dughet's inspiration, we might see just such a view, and be overtaken by just such a storm. These elements of the painting, although artfully arranged, appear real and contemporary, not transposed to the age of myths or Virgil's lifetime in the first century BC.

The disparity between actual landscape and mythical figures can be thought to imply the latter are not 'really' there: figments in the imagination of a traveller in Campania, a region forever haunted by the spirit of the great Latin poet who so memorably charted the passions of Nature, gods and mortals.

All pictures elicit stories from their viewers; this painting, and others like it, were perhaps intended to evoke the story of a daydream, visible only in the viewer's mind.

That, at any rate, is *my* story.

# TIMELESS IMAGES AND RECURRENT SCENES

Storytelling may be a universal human trait, but it seems to have evolved relatively late in the visual arts. The earliest representational images of ancient Egypt and Mesopotamia, which – unlike cave paintings – are the direct ancestors of later Western art, concentrated on two distinct themes: the timeless image and the recurrent scene.

Timeless images originally represented gods or rulers, and were meant to embody abstract ideas such as power, majesty, victory or benevolence; their pictorial formulae survive to this day in official portraits and photographs. They alluded to the life stories of the figures depicted only to help viewers identify them, and to specify which of their various aspects was being represented (see also the *Allegory Pocket Guide*).

A powerful late medieval example is this Christian cult image of the Trinity, painted in about 1410 by an unknown Austrian master [14].

The mystical Christian notion of a 'triune' God, one God in three persons, Father, Son and Holy Spirit, may be represented in various ways. In the early Middle Ages, the idea was sometimes symbolised by three faces sharing two eyes and a single nose, or by a man with three heads. When these monstrous figures were prohibited by the Church, Father and Son were shown sharing a single throne – and often, as here, a family resemblance – with the Holy Spirit 'like a Dove' soaring above. Images in which God the Father holds out the crucified Christ became popular in German-speaking countries; they signify God's loving mercy:

> *For God so loved the world, that he gave his only begotten Son, that whosoever believeth in him should not perish, but have everlasting life.*
> (John, 3:16)

Since they combine emblems of majesty – the throne, the adoring courtiers/angels – with those of God's sacrifice – the cross, blood flowing down the marble

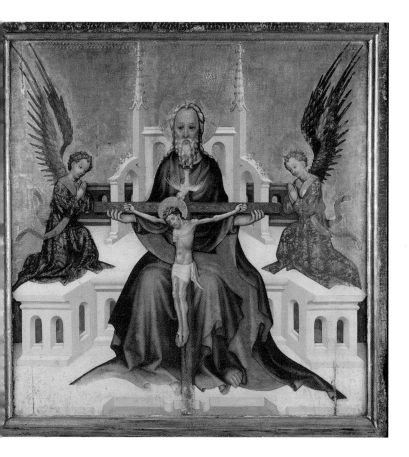

steps – images such as this are called *gnadenstuhl*, the German word for 'Throne of Mercy'.

While time is excluded from cult images, it is an obvious component of scenes representing typical and recurrent activities. The ancient Egyptians decorated their tombs with beguiling wall paintings of harvest, hunting, fishing, feasting, bringing offerings to the gods, funerals, conquest and the payment of tribute. These murals are not stories, just scenes of daily life, ordinary days on which 'nothing happens'. In the same way as Jean-François Millet's anonymous *Winnower* typifies a French peasant [15], or Camille Pissarro's *Little Country Maid* a housemaid [16], so the people depicted there are defined only by their occupations. Even when the tomb owner himself appears spearing fish or hunting hippopotamus, what is shown is not a specific occasion but the standardised pastimes of Egyptian noblemen.

14. Austrian, *The Trinity with Christ Crucified*, about 1410. 118.1 × 114.9 cm.

15. Jean-François
Millet,
*The Winnower*,
about 1847–8.
100.5 × 71 cm.

16. Camille
Pissarro,
*The Little Country
Maid*, 1882.
63.5 × 53 cm.
On loan to the
National Gallery
from Tate,
London.

The same designs recur from tomb to tomb, and all speak of an ever-present condition, recurrent as the rising and setting of the sun. Small wonder that a circle, formed by a snake biting its own tail, was an ancient emblem both of time and of eternity.

The medieval equivalents of Egyptian tomb paintings were the 'Occupations of the Months', pictured in churches and on the calendar pages of prayer books. These in turn inspired works such as Hans Wertinger's, probably a fragment from a domestic decoration painted around 1525 [17]. It shows activities appropriate to summertime: reaping grain, hunting, shearing sheep and taking produce to market [18]. Just visible in the right foreground is a cart with a woman sitting on it, presumably on her way to *Autumn* on a now-lost adjacent panel.

Directly descended from such images are the paintings of 'everyday life' that became popular in the Low Countries after 1600. Today, the intended significance of some of these genre pictures is much harder to grasp than that of seasonal images – yet, although their appearance and aims are different, they were equally intended to depict typical and recurrent pursuits.

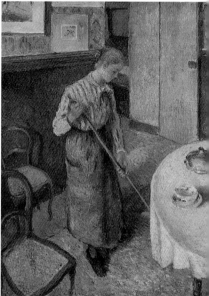

17. Hans
Wertinger,
*Summer*,
about 1525.
23.2 × 39.5 cm.

18. Detail of 17.

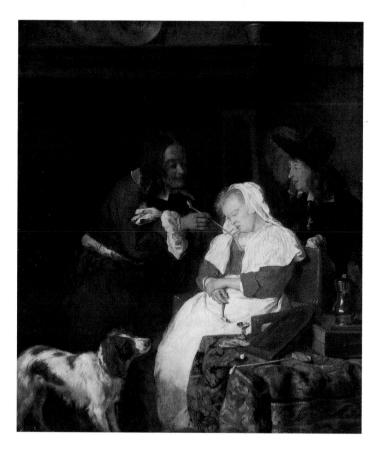

19. Gabriel Metsu,
*Two Men with a
Sleeping Woman*,
about 1655–60.
37.1 × 32.4 cm.

The Dutch painter Gabriel Metsu's *Two Men with a Sleeping Woman* certainly leads us to wonder what led up to this scene and what will happen next [19]. The woman has been smoking, playing cards and drinking in a tavern: the cards, another clay pipe, an innkeeper's slate and a wine pot are displayed on the table. She may be a serving maid, or the innkeeper's wife, and the two men seem to be mocking her; the one on the left is using the stem of his own pipe to part the collar of her bodice.

In a nearly contemporary work by Metsu's compatriot Jan Steen [20], another woman has fallen asleep after smoking and drinking. This time one of her louche companions is blowing smoke in her face [21].

These are not two versions of the same story. There are scores of similar pictures by seventeenth-century Dutch and Flemish artists, and the men and women they show behaving badly are no more individuated than Millet's *Winnower* [15] or Wertinger's

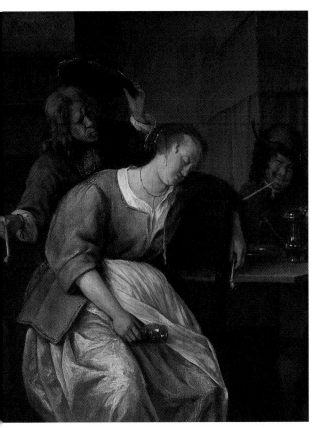

20. Jan Steen,
*A Man blowing
Smoke at a
Drunken Woman,
Another Man with
a Wine-pot*,
about 1660–5.
30.2 × 24.8 cm.

21. Detail of 20.

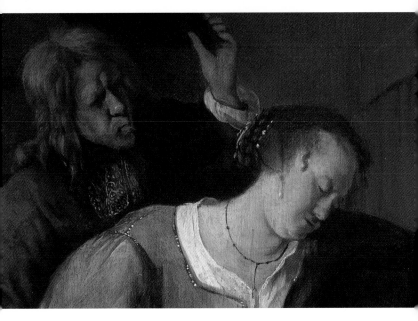

22. Jan Steen, *A Peasant Family at Meal-time ('Grace before Meat')*, about 1665. 44.8 × 37.5 cm.

peasants [17]. They are anonymous wastrels, counter-examples of the virtuous life also often typified in Dutch genre paintings [22].

Pictures of life misspent in the tavern were not intended to give free rein to viewers' storytelling imagination, but to prompt them to recall the 'timeless' admonitions of the Bible:

> *Wine is a mocker, strong drink is raging: and whosoever is deceived thereby is not wise.*
> (Proverbs 20:1)

> *Who has woe? who hath sorrow? who hath contentions? who hath babbling? who hath wounds without cause? who hath redness of eyes? They that tarry long at the wine; they that go to seek mixed wine. Look not thou upon the wine when it is red...* (Proverbs 23:29–31)

> *How long wilt thou sleep, O sluggard? when wilt thou arise out of thy sleep? Yet a little sleep, a little slumber, a little folding of the hands to sleep: So shall thy poverty come as one that travelleth...* (Proverbs 6:9–11)

Not only did the Bible predict the consequences of drinking – babbling and redness of eyes – and sluggardly slumber – poverty – but it also foresaw the new, time-wasting vice of smoking: 'For my days are consumed like smoke' (Psalm 102:3).

In sugar-coating with humour the bitter pill of good counsel, seventeenth-century genre painters followed the example of a great Dutch scholar, Desiderius Erasmus, in his ironic *Praise of Folly*, written for Thomas More in 1509 and popular for centuries thereafter. As Erasmus said, 'truth finds a way into the minds of men more agreeably, and with less danger of giving offence, by favour of these pleasantries' (*Adages*, 1515 edition, (j) *To make a show of kitchen pots*').

In a complex society like that of the prosperous Dutch Republic, aspiring to virtue yet drawn to gin, scenes such as these seemed to record, and warn against, perennial and typical – eternal and universal – examples of human folly [23].

23. Adriaen Brouwer, detail from *Tavern Scene*, about 1635. 48 × 76 cm.

# NARRATIVE IMAGES
# AND TEXTS

Narrative images, like pictures of typical occupations or conditions, can point a moral, but they embody a linear, rather than cyclical, conception of time. It has been said that if the ancient metaphor for time was the serpent biting its own tail, the notion of time as a straight line is characteristic of the Judeo-Christian tradition, which maintains that time progresses from Creation to the end of the world, and defines Eternity as an absence of time.

Of course stories and their illustrations are much older than even the earliest books of the Bible. The earliest narrative images were made to celebrate particular triumphs of rulers or city states in the Ancient Near East. The historic events and their protagonists are identified through inscriptions, such as the cuneiform writing carved on the sugar-loaf mountain in the famous *Victory Stele of Naram Sin*, dated to the twenty-third century BC and now in the Louvre [24].

The victorious Babylonian King, Naram Sin, is recognisable by being larger and more splendid than the other figures. He wears a horned helmet and carries a bow and spear or sceptre. The parallel ranks of climbing soldiers draw the eye upward to focus on him as he tramples a dead foe, towering over another who is wounded and a third pleading for mercy. Yet the carving on this stone slab merely symbolises victory; it does not represent decisive events in the battle. The stele is attributable to an individual king and a particular conquest only by virtue of the inscription.

Texts were for a long time intrinsic to narrative representation. Although images more readily engage our attention and arouse our emotions, they convey information less precisely than words. As the art historian E. H. Gombrich points out, the image of a cat on a mat unaccompanied by text cannot specify 'this is my cat Tom', much less that 'there is no elephant on the mat'.

In *Art and Illusion*, Professor Gombrich attributes the development of truly narrative images to what he

24. *Victory Stele of Naram Sin*, about 2300–2200 BC. 200 × 105 cm. Musée du Louvre, Paris.

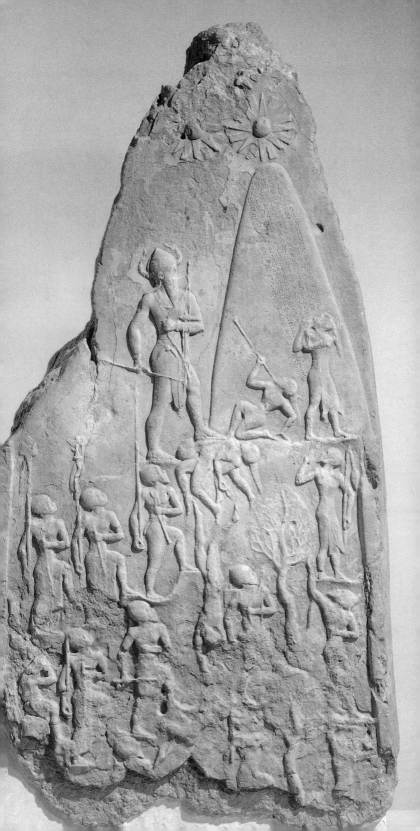

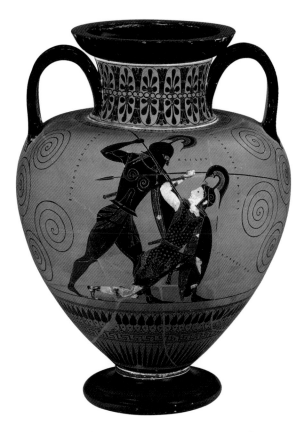

25. Exekias, black-figured amphora showing Achilles killing Penthesilea, about 540–530 BC. Height 41.6 cm. The British Museum, London.

calls the 'Greek revolution'. From the time of Homer, Greek poets 'had the licence to vary and embroider their accounts of mythical events'. As a consequence, visual artists were granted a similar freedom. Instead of continuing to use the schematic patterns of Near Eastern art to restate the timeless truths embodied by myths, they sought to show how the mythical events might have appeared to witnesses or participants.

Many Greek myths were first illustrated on pottery with the names of the protagonists inscribed near the figures. This wine jar [25], made in Athens around 540 BC, shows the Greek hero Achilles killing the warrior Queen of the Amazons, Penthesilea, in one of the bloody battles of the Trojan War (see page 35). In time, these tales, told and retold by poets, became so well known that artists could increasingly rely on viewers to supply the story from purely visual clues.

Conversely, the popularity of certain myths in art may have ensured their survival in collective memory. A case in point is the story of the Judgement of Paris.

The legend must have been known to Homer, for he refers to it briefly in the *Iliad*, but it seems not to have been written down until the second century AD, by the mythographer Hyginus and the satirical poet Lucian. The story of this 'pastoral beauty contest' had been kept alive for nearly eight hundred years – almost certainly because of the vivid allure of the many images it inspired (the earliest known decorates a Greek vase from the sixth century BC). The Judgement of Paris is said to be the most often pictured mythical subject; even today many people encounter it first in pictures, such as the two paintings by Peter Paul Rubens now in the National Gallery.

It is easy to see why the great seventeenth-century Flemish artist was attracted to the theme, and returned to it throughout his career. It enabled him to combine two of his favourite motifs – landscape and the female nude – with reference to classical antiquity, whose art and literature he admired and knew well (he had certainly read Lucian). The version reproduced here is dated to the 1630s [26].

The story begins with a golden apple, inscribed 'For the Fairest', thrown down at a banquet of the gods by an uninvited guest, Eris, goddess of strife.

26. Peter Paul Rubens, *'The Judgement of Paris'*, probably 1632–5. 144.8 × 193.7 cm.

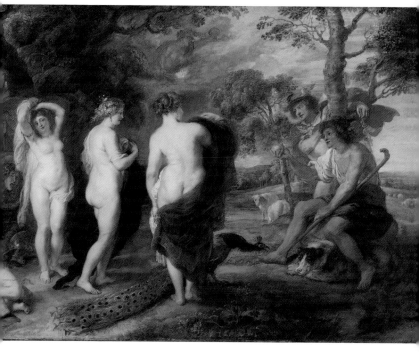

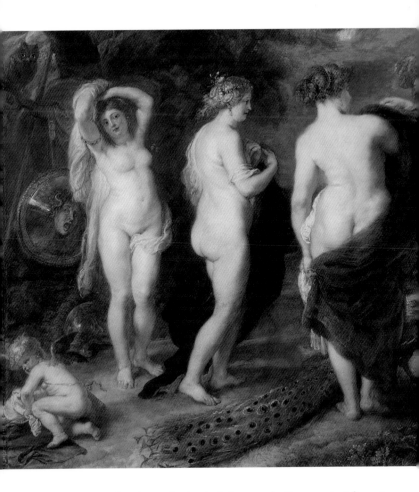

27. Detail of 26. Jupiter, refusing to intervene in the ensuing dispute, charged Mercury with leading Juno, Minerva and Venus to Mount Ida, where Paris, Prince of Troy, could act as arbiter. In order to decide which goddess was most beautiful, Paris asked all three to undress. His award of the golden apple to Venus would cause the destruction of Troy by the Greeks – as predicted by an oracle when Paris was born. For this reason, Paris had been abandoned as an infant on Mount Ida, only to be rescued and reared by a shepherd.

In Rubens's painting we find the shepherd-prince seated under a tree, his flock grazing peaceably nearby; Mercury in his winged hat, his cape still airborne, has alighted beside him [28]. Minerva, on the left, has set down her helmet, her shield with the Gorgon's head, and her owl *alter ego*, and is shedding her last remaining garment. Meanwhile, Juno, on the

right, gathers up her fur-lined cloak, and Venus, in the centre, modestly clutches her wrap to her breast as she steps towards Paris [27]. They both perceive what Minerva has not yet noticed: that the besotted youth is about to hand the apple to the goddess of love. Juno had offered to make him the richest man alive; Minerva to make him wise and victorious in battle – but Venus had promised him Helen, wife of the King of Sparta, a woman as beautiful as the goddess herself.

28. Detail of 26.

It will be to recover Helen, abducted by Paris, that the Greeks will go to war against Troy.

Paris sits with both feet on the ground, but due to the tendency of oil paints to grow transparent with age, we can still see an earlier version in which his right leg is raised in the air [28] – a clear allusion to sexual arousal, which Rubens repented of and painted out.

29. Detail of 26.

The alteration, however, hardly lessens the erotic mood, tinged with irony and nostalgia, of the picture as a whole. The three goddesses present the viewer – as much a voyeur as Paris – with three aspects of the female nude: front, back and side. (Who dares to say that painting cannot compete with sculpture in showing figures in the round?) Juno's peacock screeches with a loser's spite at Paris' sheepdog [28]. Cupid, his mother's willing accomplice, slyly bundles up Venus' undergarments [27].

Meanwhile, unheeded by those below, dark clouds gather in the sky; among them rides Alecto, the Fury of war, bearing a lighted torch [29].

Rubens is one of the most consummate narrative painters who ever lived. No verbal description can match the immediacy and sensuality of this image, its poignant intimation that neither pastoral idyll, nor the bright loveliness of golden afternoons and youthful desire, can long withstand night's advancing shadows, and the ravages of war.

Yet even Rubens requires a text to explain how seemingly trivial causes may bring about consequences displeasing to the gods and fatal to humans.

Less picturesque tales, seldom represented in art, are more readily forgotten and it becomes in turn increasingly difficult to identify the literary sources of the rare images they inspire.

Until recently, no modern viewer was able to unravel the meaning of Domenico Beccafumi's panel of about 1540, probably part of the interior decoration of a *palazzo* in the artist's native Siena [30]. His clients, having either requested or agreed the subject, did not require explanatory inscriptions. We can imagine them proudly satisfying the curiosity of their admiring but puzzled friends by relating the picture's story to them – stories, after all, are meant to be shared with others.

It has long been supposed that the setting is a playful reconstruction of ancient Rome. Beyond the bridge on the right stands the papal fortress of Castel Sant'Angelo, originally built to house the Emperor Hadrian's tomb; through the airy opening left of centre we recognise the Colosseum and the triumphal Arch of Constantine [31]. The figures are mostly women in 'antique' fancy dress, who direct our gaze to the stately building in the middleground. Inside, a woman and her companions appear before a man seated on a throne.

Trying to make sense of all this, art historians suggested ancient stories of heroines defying male authority: Virginia, coveted by a corrupt Roman judge; Esther before Ahasuerus; the Queen of Sheba before Solomon; or Saint Lucy refusing to recant her

30. Domenico Beccafumi, *The Story of Papirius*, probably 1540–50. 74 × 137.8 cm.

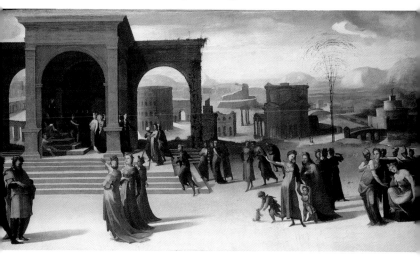

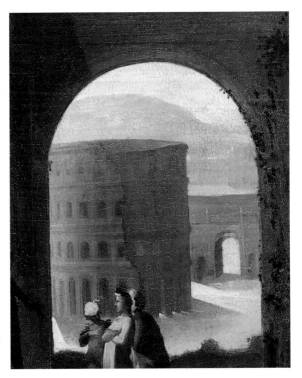

Christian faith. Yet none quite fits the picture, which continued to be shown with the label *An Unidentified Scene*.

When the painting was re-examined in 2001, however, previously overlooked details were noticed, and the text that inspired Beccafumi was finally identified – accounting at a stroke for the setting and all the incidents of the picture, its light-hearted mood, and its function in a domestic interior.

Far from celebrating female virtue, the tale contrasts the foolishness of women with the patriotism and nimble wit of a boy. The little-known story is that of Papirius Praetextatus, as told in the *Attic Nights*, a medley on various topics compiled by the second-century Latin writer Aulus Gellius.

Young Papirius had gone with his father to the Senate on a day when an important matter had been discussed and the decision postponed. It was voted that no one should mention the subject of the debate until the matter was decided. But Papirius' mother pressed the reluctant boy to reveal to her the Senate's secret deliberations; this is the episode depicted in the

38

background at the extreme left [32]. Unable to resist her entreaties, Papirius resorted to an inventive lie. He told her that the senators were discussing whether it was more to the advantage of the Roman state for one man to have two wives, or one woman to have two husbands.

On hearing this, his mother rushed in alarm to spread the news to other women. The next day, to the bafflement of the men [33], a crowd of matrons led by Papirius' mother converged on the Senate to petition that one woman might have two husbands, rather than one man have two wives.

While the senators wondered 'at this strange madness of the women and the meaning of such a demand', Papirius stepped forward and explained what had happened. Beccafumi shows him standing on the steps inside the Senate House, gesturing in the direction of his mother, who places her hand on her breast in surprise or dismay [34].

The Senate voted that from then on no children except Papirius would be allowed to accompany their fathers to the House, honouring the boy's discretion and quick wit with the surname Praetextatus. This refers to the *toga praetexta*, the purple-bordered upper garment – here depicted all purple – worn by freeborn boys too young to assume the *toga virilis* of adult citizens.

This exemplary tale about putting the interests of the republic before family loyalty was an appropriate theme for the decoration of a patrician residence in republican Siena; it wears its sexual politics lightly enough to amuse women as well as children and the paterfamilias.

Beccafumi relies in this picture on the convention known as 'continuous narrative' (page 13): the protagonists of the story reappear within a continuous pictorial space, cleverly punctuated by architecture.

Of the three main modes of pictorial narration, 'continuous narrative' is the least illusionistic: this is not how things appear to us in reality. But Beccafumi's panel was designed – like Piero di Cosimo's [2] – for a piece of furniture, and not intended to simulate an aperture through which viewers might witness an actual event. For this reason, 'continuous narrative' was retained in furniture painting long after it had been abandoned in easel pictures and murals.

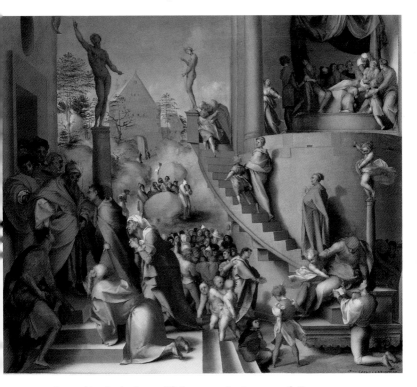

A particularly beautiful example is one of the panels Jacopo Pontormo painted for the bridal bedchamber of a Florentine banker, Pierfrancesco Borgherini, who married in 1515 [35]. The furnishings of the entire room were decorated with scenes from the life of Joseph, as recounted in the book of Genesis. The story was particularly fitting for a God-fearing and much travelled banker, since Joseph is an exemplar of prudence and generosity, who with God's

35. Jacopo Pontormo, *Joseph with Jacob in Egypt*, probably 1518. 96.5 × 109.5 cm.

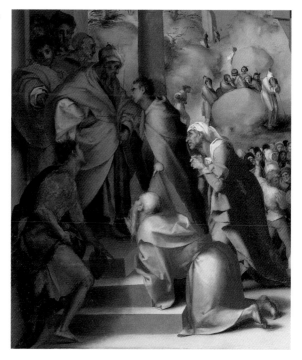

help prospers in a foreign land, and is thus able to assist others in time of need. As both an innocent victim of his brothers' envy and the saviour of his people, he is also, in theological teaching, one of the main Old Testament characters thought to prefigure Jesus Christ.

In the most admired of his panels, showing the climactic episodes of Joseph's life as Viceroy of Egypt, Pontormo depicts the hero four times. We recognise him by his red cap, lavender cloak and amber tunic. In the left foreground, Joseph presents his father Jacob to Pharaoh [36]. In the right foreground, he leans down from his chariot to a kneeling messenger bearing news of his father's illness [37]. In the right middle distance, he climbs up a winding staircase with one of his sons, to visit the dying Jacob [38]. In a chamber, upper right, he presents his sons Ephraim and Manasseh at Jacob's bedside to receive their grandfather's blessing [39] (Genesis 47–48).

There are many haunting and poetic passages in this painting, but I want to call your attention especially to the way Pontormo exploits the technique of 'continuous narrative' to tell the story on a nearly

37, 38, 39.
Details of 35.

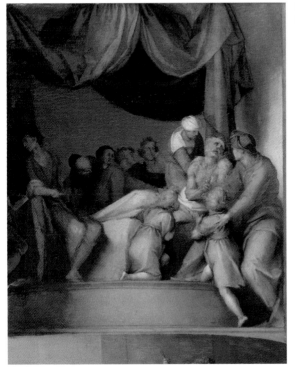

43

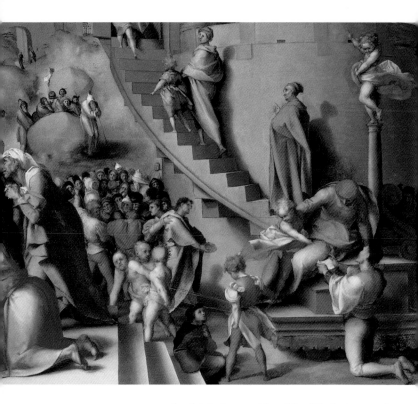

40. Detail of 35.

square panel, which does not lend itself to being read from left to right. The first episode, in the lower left corner – the presentation of Jacob to Pharaoh – and the last, in the upper right corner – the presentation of Joseph's sons to Jacob – are connected by an implicit diagonal across the surface of the panel; the same diagonal functions according to the rules of perspective to suggest recession from front to back. The earlier episodes in the story are nearest the viewer. The winding staircase accentuates a similar diagonal from lower right to upper left, but here the forlorn figures in the distance allude to past events: Jacob's arrival in Egypt to seek grain.

This dynamic X-shaped composition is firmly anchored on the picture plane by stable vertical and horizontal lines – columns, edges of walls, the base of Joseph's chariot and the steps of Pharaoh's palace – while the movement from foreground to background is accelerated by the four receding lines of palace steps in the centre, pointing towards the hungry crowds pressing forward, their representative being urged, cap in hand, towards Joseph's chariot [40].

(The little boy seated on the steps is said to be a portrait of Pontormo's pupil, Bronzino, who later became a famous painter in his own right.)

The close perusal required by narrative furniture paintings such as Beccafumi's and Pontormo's is very different from that appropriate to most other pictures. Although it may not proceed in an orderly left-to-right fashion, it is more akin to reading a written text, in which the passage of the reader's time coincides with the progress of time in the story.

I have always envied the children in Renaissance palaces, who grew up with works like these – on storage chests, benchbacks, the head- and footboards of beds – for picture books.

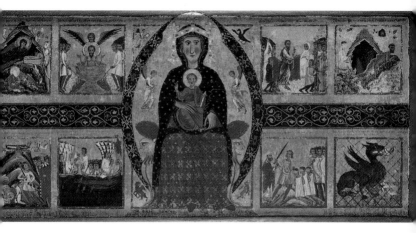

For those who can read, textual inscriptions exclude the possibility of ambiguity or error in interpreting images. But even to the illiterate, the written word signifies solemnity and authority – *Scripture* originally merely meant 'a piece of writing'. For many centuries, inscriptions in Latin, the language of scholarship and the Catholic Church, lent authority to pictures even for those who could not read them.

It is unlikely that anyone but the priest at the altar would have been able to decipher the now much-effaced Latin inscriptions on Margarito's altarpiece panel, one of the earliest paintings in the National Gallery [41]. Their particular interest for us is that they distinguish the smaller narrative scenes on either side from the timeless image of the Virgin and

41. Margarito of Arezzo,
*The Virgin and Child Enthroned, with Scenes of the Nativity and the Lives of the Saints*, 1260s.
92.5 × 183 cm.

Child in the centre. Perhaps a priest would not have needed the texts to identify all these scenes correctly, but clearly the painter and his patrons were taking no chances.

Except for the one captioned *Concerning the Virgin Mary giving birth and the Annunciation to the Shepherds*, the narrative panels represent key episodes from the lives of five saints. Saints John the Evangelist and Nicholas each have two scenes dedicated to them; Saints Benedict, Catherine and Margaret only one, although each of the women saints appears twice within a single setting, enabling Margarito to depict both her martyrdom and its miraculous sequel.

Saint Margaret inspired perhaps the freshest and most dramatic of these little pictures [42]. Thrown into a dungeon for refusing to marry the Prefect of Antioch, the Christian virgin was devoured by Satan in the form of a dragon. But the cross she held caused the monster to split open, releasing her unharmed. We see her here, through a grid of prison bars, first being swallowed, then emerging from the dragon's belly. The damaged caption above reads, 'Here Saint Margaret [in the dragon's] mouth [escapes] when his entrails burst'.

42. Detail of 41.

Short and to the point, text and image – featuring a heroine and a monster – represent the legend that caused this virgin martyr to be adopted as the holy protector of women in childbirth, and thus one of the most popular of saints. (Alas, since there is no evidence for Margaret of Antioch's factual existence, she was removed from the calendar of saints in 1969.) Saint Margaret naturally also became a frequent subject of 'timeless' devotional images. One of the most appealing was painted in the 1630s by the Sevillan artist Francisco de Zurbarán [43]. It shows how readily narrative elements may be reduced to identifying attributes. The terrible dragon has become a mere 'companion animal' – although the saint's Spanish shepherdess costume refers to a particular period in her life, when she lived in the country caring for her nurse's sheep.

43. Francisco de Zurbarán, *Saint Margaret of Antioch*, 1630–4. 163 × 105 cm.

44. Pisanello, *The Vision of Saint Eustace*, mid-fifteenth century. 54.5 × 65.5 cm.

We have come full circle. The inscriptions in Margarito's painting of the 1260s identify stories the artist was not confident he could communicate by visual means alone. By the 1630s, pictures had made the stories so familiar that visual attributes could replace texts. Zurbarán did not need to inscribe his painting *Saint Margaret of Antioch*, for that is what his dragon tells the viewer.

Pisanello's *Vision of Saint Eustace* is less easily classifiable as a narrative painting or a timeless image [44]. Eustace's attribute – the only way we can recognise him – is his vision of a stag with a crucifix between its antlers, which brought about his conversion to Christianity while he was out hunting. By expanding the composition to include hunting dogs, woodland animals and birds, is Pisanello evoking the entire legend of the saint – or merely embellishing a timeless devotional image with details pleasing to his aristocratic patrons? Is the presence of Saint Eustace only a pretext, enabling Pisanello to show off his gifts of naturalistic depiction?

Timeless devotional painting or narrative? Relgious or secular image? It is a question viewers must answer for themselves: I doubt it would much have bothered the artist.

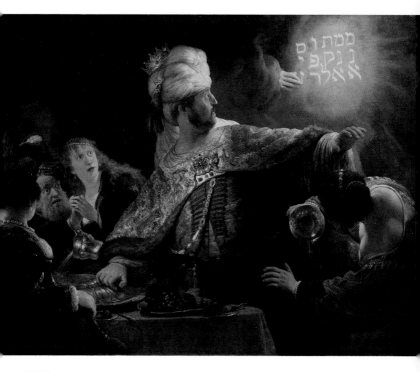

There is one famous story that hinges on a text being undecipherable – and an undecipherable text provides the inscription when the story is pictured. The Old Testament Book of Daniel (5: 1–6, 25–8) tells the dramatic tale of Belshazzar's Feast, the subject of one of Rembrandt's most spectacular paintings [45].

Belshazzar, the King of Babylon, gave a great feast, at which guests ate and drank out of the gold and silver vessels looted from the Jewish temple in Jerusalem by his father, Nebuchadnezzar. The diners then praised false Babylonian gods instead of the one God of the Hebrews. From nowhere there 'came forth fingers of a man's hand and wrote...upon the plaister of the wall'.

Rembrandt's Dutch contemporaries knew their Bible. They remembered the consequences of the scene – that no one but the Jewish seer Daniel

45. Rembrandt, *Belshazzar's Feast*, about 1636–8. 167.6 × 209.2.

The Hebrew text shown in the image (read right to left):

מ מ ת ו ס
י נ ק פ
ת א ל ר

46. Detail of 45.　could decipher the words *MENE, MENE, TEKEL, UPHARSIN*, which foretold the death of the King and the division of his kingdom. They were also aware that scholars still argued about why no one else had been able to read the fatal inscription.

Menasseh ben Israel, Rembrandt's learned Jewish friend and neighbour, proposed a rational explanation. He believed that instead of being written horizontally from right to left in the normal way of Hebrew script, the words had been inscribed vertically, as Rembrandt pictures them [46]. Menasseh only published his theory some time after the painting was made, but we can assume that Rembrandt and he had discussed it earlier. Did Rembrandt go to Menasseh to help him with his picture, or did Menasseh's study of the biblical text first inspire the artist?

Either way, hardly any of the painting's original viewers, even those who knew Hebrew, could have read the writing on the wall with ease. Everything in this picture – the cinematic 'close-up' focus on the figures; their startled gazes, open mouths and agitated gestures; the wine spilling out of the sacred vessels; and, above all, the mysterious inscription whose significance we guess only too well – conspires to make us feel like participants in the sacrilegious feast, sinful debauchees forgetful of the true God.

Had the picture hung, as it possibly did, in a dining room, it would certainly have prompted the diners to say grace before meat.

50

# NARRATIVE AS THE PAINTER'S 'GREATEST WORK'
## *ISTORIA*

Rembrandt's table-top, 'close-up' format brings the story of Belshazzar's Feast home. But it also enabled him to represent half-length figures on the scale of life, on a canvas of moderate dimensions – to paint a domestic picture that preserves the monumentality of painting for public viewing.

Why this should have mattered to Rembrandt is answered by one of the most influential books on art ever written: Leon Battista Alberti's *On Painting*, composed around 1435 first in Latin then in Italian, to champion the recent achievements of a group of innovative Florentine artists working mainly on large public commissions for churches, guilds and the city. For the benefit of painters and patrons elsewhere, Alberti, a humanist scholar and architect, expounded the theoretical bases of the new style, adding recommendations based on his own knowledge of mathematics, classical literature, art and archaeology.

A striking feature of the Florentines' innovations was their use of scientific methods to match art more closely with reality. An interest in optics and geometry prompted Filippo Brunelleschi's invention of 'single vanishing-point' perspective, enabling artists to construct a fictive world parallel to the viewers' own. The study of anatomy also allowed them to people apparently three-dimensional pictorial spaces with convincingly lifelike figures.

But realism for its own sake was neither the artists' nor Alberti's goal. Their aim was to rival in a modern idiom the grandeur of ancient Graeco-Roman art and, above all, the persuasive power of oratory, epic poetry and drama.

*Istoria*, you will recall, was the Italian word once used merely to differentiate narrative from timeless images (page 13). Alberti applied it to an intellectually ambitious art that challenges artists and profoundly engages viewers:

*The greatest work of the painter is not a colossus, but an* istoria. Istoria *gives greater renown to the intellect than any colossus.* (Alberti, *On Painting*, trans. John R. Spencer, New Haven and London, 1966, Book Two, p. 72)

*The* istoria *which merits both praise and admiration will...capture the eye of whatever learned or unlearned person is looking at it and will move his soul...* (Ibid., p. 75)

Medieval Italian painters had dazzled viewers of religious pictures by evoking celestial splendour through elaborately worked gold and silver, precious pigments and figures of rarefied elegance. The avant-garde artists admired by Alberti awed spectators by convincing them of the bodily existence of Heaven, and elicited their empathy by introducing narrative incidents even into symbolic 'timeless' images.

Masaccio's enthroned *Virgin and Child* [47] are represented as fully physical beings in a material environment – note the true-to-life distribution of light and shadow, particularly on the 'perspectivised' lutes of the angels at the foot of the throne. But the compelling realism extends also to the plump baby Jesus sitting naked on his Mother's lap. He has evidently just tasted a grape from the bunch in her hand, and now contentedly sucks his fingers in a gesture surely based on Masaccio's observation of the behaviour of real infants.

In the context of a Christian altarpiece, however, grapes symbolise the wine of the Eucharist, the Redeemer's blood shed on humanity's behalf. The child's appetite for the fruit signifies Christ's eager acquiescence in the Passion; the Mother's melancholy gaze signals helpless foreknowledge of his, and her own, sufferings.

By translating religious symbolism into a 'human interest' story, Masaccio's painting engages even the most unlearned viewer with the central mysteries of the Christian faith as no traditional image of an impassive 'miniature adult' Christ Child, extending his hand in blessing, could ever do.

Piero della Francesca's *Baptism of Christ* [48], painted some twenty years after Alberti wrote his treatise, is a more obvious example of religious *istoria*,

since its subject – the first manifestation of Christ's divinity – is a story recounted in the Gospels. Piero relocates the River Jordan from Palestine to the rolling hills near his native town of Borgo San Sepolcro. The familiar sunlit setting, the convincing foreshortening of the hovering dove of the Holy Spirit and of Saint

47. Masaccio, *The Virgin and Child*, 1426. 135.5 × 73 cm.

53

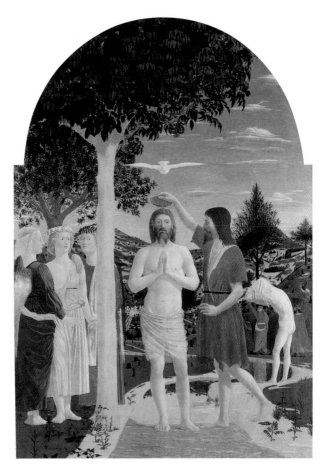

48. Piero della Francesca, *The Baptism of Christ*, 1450s. 167 × 116 cm.

49. Detail of 48.

John's baptismal bowl – and the still more difficult foreshortening of Christ's feet, firmly planted in the shallow river at the point where the water is seen to change from transparent to reflective [49] – all intimate that viewers of this altarpiece were not merely intended to venerate a holy image, but to witness a real event capable of changing their lives as it changed those of its protagonists.

Alberti advised extending the repertory of *istoria* to secular themes, notably those treated by ancient authors. There had long been a tradition in Italian art of exemplifying the virtues through 'portraits' of famous men and women – but not every spectator could be counted on to know which virtue, and why, each represented. By showing these heroic figures acting out their noble deeds, artists could more readily persuade viewers to follow their example.

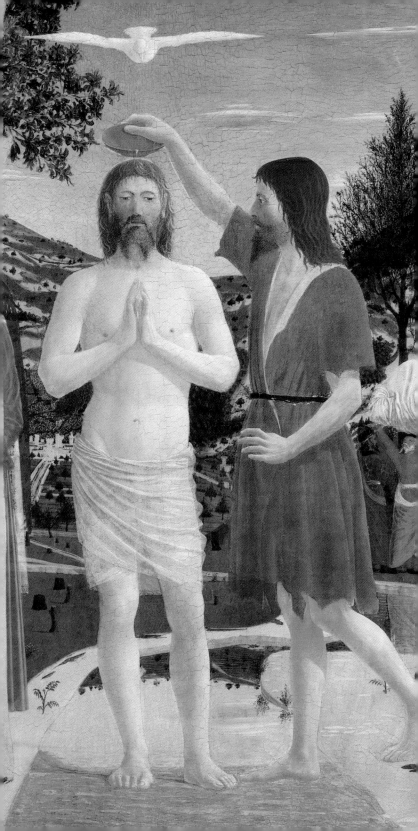

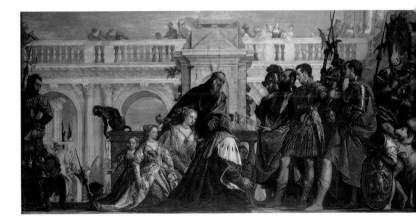

50. Paolo Veronese, *The Family of Darius before Alexander*, 1565–70. 236.2 × 474.9 cm.

Veronese's *Family of Darius before Alexander* [50], painted in the Veneto in the late 1560s, dispenses with elaborate perspective to focus on the action in the foreground. (The huge painting was designed to be seen from below; to show the floor receding into the distance, as if seen from above, would have contradicted the spectators' actual point of view.)

As in Solimena's *Dido receiving Aeneas* [8], some figures are in contemporary dress, others in fancy-dress, for this is a costume drama drawn from the

51. Detail of 50.

life of Alexander the Great, as told by the ancient historians Valerius Maximus and Plutarch.

After the Battle of Issus in 333 BC, where he had defeated the Persian Emperor Darius, Alexander magnanimously sent word to Darius' family that the Emperor was alive, and they themselves would not be harmed. The following morning he went with his dearest friend and general, Hephaestion, to visit them. The Empress Mother Sisygambis [51] – shown here wearing the ermine collar of a Venetian doge's wife – prostrated herself before Hephaestion, mistaking him for Alexander. With exquisite courtesy, Alexander forgave her dangerous gaffe, saying, 'It is no mistake, for he too is an Alexander.'

To Alexander's magnanimity, clemency and the capacity for friendship is added the virtue of 'continence' or chastity, for the victorious hero declines the offer – signalled by Sisygambis' pointing hand – of Darius' beautiful wife, shown kneeling behind the Empress Mother.

Like Darius' court, we are left in momentary confusion as to which of the two leading warriors entering from the right is Alexander (he is almost certainly the figure in red 'Roman armour') [52].

52. Detail of 50.

Having thus been drawn into the story, we can all the more readily grasp the moral – and be moved to emulate the virtues of Alexander the Great, conqueror not only of the world but also of his own baser instincts. The original owners – private as it happens – of Veronese's great *istoria* thus demonstrated their own allegiance to civilised values.

Alberti had devoted a significant part of his treatise to the geometry of perspective. From the sixteenth century onwards artists turned more eagerly to the other major concern of his book:

53. Annibale Carracci, *The Dead Christ Mourned ('The Three Maries')*, about 1604. 92.8 × 103.2 cm.

*The* istoria *will move the soul of the beholder when each man painted there clearly shows the movements of his own soul ... we weep with the weeping, laugh with the laughing, and grieve with the grieving.* (Ibid., p. 77)

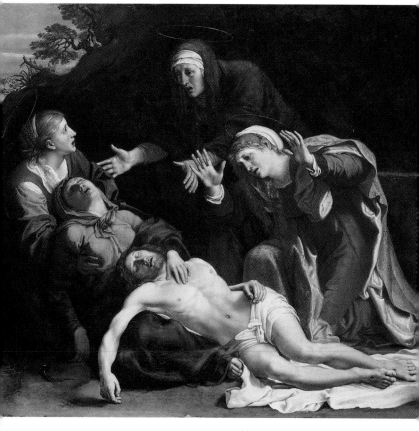

The 'motions of the soul', which Alberti also calls the *affetti*, are the emotions, shown through the 'motions of the body'. What poses, gestures and expressions manifest which emotions or states of being, and what emotions should be expressed by different characters in various situations (or by different characters reacting to the same situation), became a burning topic of study and discussion among European artists and spectators.

The expression of emotion in Masaccio's, Piero's and Veronese's paintings was constrained by religious or courtly etiquette. Some themes, however, demanded a greater show of feelings from the painted characters, and a more emotional response from viewers.

Even today, only an insensitive viewer could misinterpret the feelings of each of the four women mourners in Annibale Carracci's *Dead Christ Mourned* ('*The Three Maries*') [53] – and only a very inattentive one could mistake the dead body of Christ for a man who has merely fainted.

Writing of an ancient relief showing the dead mythological hero, Meleager, Alberti insists on this particular point:

> An istoria *is praised in Rome in which Meleager, a dead man, weighs down those who carry him. In every one of his members he appears completely dead – everything hangs, hands, fingers and head; everything falls heavily. Anyone who tries to express a dead body – which is certainly most difficult – will be a good painter, if he knows how to make each member of a body flaccid...The members of the dead should be dead to the very nails; of live persons every member should be alive in the smallest part.* (Ibid., pp. 73–4)

Throughout his treatise *On Painting*, as I have stressed, Alberti champions *istoria* as the rival of epic poetry, drama and public oratory, able to move and elevate the soul of any and every viewer. Consequently, he insists, painters of *istoria* require the same imaginative, intellectual and moral qualities as writers and orators.

With Alberti and the Italian Renaissance, the 'Greek revolution' (page 32) was explicitly fulfilled; painters and sculptors were raised above 'mere

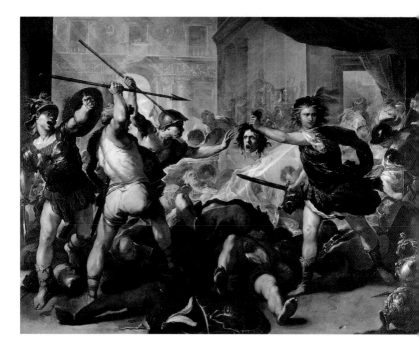

54. Luca Giordano, *Perseus turning Phineas and his Followers to Stone*, early 1860s. 285 × 366 cm.

craftsmen' to become 'liberal artists'. Yet to qualify for the higher status, they had to meet certain criteria. To move souls, they could not simply cater to rich people's love of luxury. To elevate souls, they had to represent noble subjects, actions worthy of emulation. And to reach everyone, they were preferably to work in public spaces, on a large enough scale to affect an entire community of viewers.

Protestant abhorrence of 'image worship' in the north, and the rise of private collecting throughout Europe, made it increasingly rare for seventeenth-century artists to receive public commissions of the kind advocated by Alberti. Some turned to edification through Erasmian irony, painting small pictures for domestic interiors, of people 'like ourselves or worse' [see 19, 20]. Those who aspired to greatness within the Italianate Renaissance tradition continued to paint *istoria* as best they could.

At nearly three metres high by four metres wide, with full-length figures on the scale of life, Luca Giordano's *Perseus turning Phineas and his Followers to Stone* is one of the largest narrative pictures in the National Gallery [54]. It captures a climactic moment from the fable of Perseus in Ovid's *Metamorphoses* (Book v, 1–235). The hero, having rescued Andromeda

from a sea monster to which she was being sacrificed, had claimed her hand in marriage. But the princess was already betrothed to Phineas. Having earlier abandoned her to her fate, he now bursts into the wedding feast with armed followers, to claim her for himself. Outnumbered, Perseus uncovers his secret weapon: the snake-haired head of the gorgon Medusa, sight of which turns men to stone.

As Perseus averts his own gaze, we witness the sudden petrifaction of Phineas and his men: they are turning grey from head to toe before our very eyes [55]. Phineas, on the far left, has let his men go in front of him, and is shown up as a cowardly villain: good triumphs over evil.

And yet this painting is not precisely an *istoria*

55. Detail of 54.

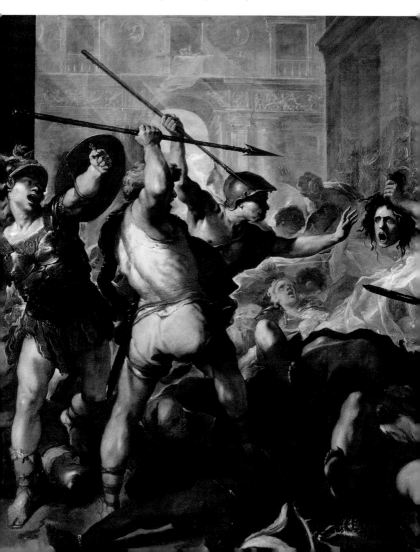

that elevates viewers' souls, despite apparently following Alberti's prescriptions. Perseus' victory is not assured by heroic virtue alone, but by magic. We, the viewers, risk being turned to stone along with Phineas, not because we join him in wrongdoing but because we are made to gaze upon Medusa's head. It is the magic of Giordano's brush that moves us (or, rather, causes us to stand petrified). While Veronese's *Family of Darius* [50] exemplified virtue, this is a picture procured by rich patrons for their own delight and the amazement of their guests.

Rembrandt, seldom having vast wall spaces at his disposal, had to work with less. The domestic format of *Belshazzar's Feast* [45] does not permit full-length figures, but they are painted on the scale of life. The picture may not record a heroic action, yet it represents a divine miracle and the downfall of a king, and warns against mocking God. Rembrandt would probably have welcomed its removal from a private interior to a public gallery – as late in life he welcomed his only chance to paint a monumental *istoria* for a public location. Sadly, within a few years that painting, *The Oath of the Batavians under Claudius Civilis*, was removed from Amsterdam's New Town Hall, cut up, and the remaining fragment sold. It now hangs in the National Museum, Stockholm, but the grandeur of Rembrandt's challenge to the great Italians can only be deduced with the help of his preparatory drawing for the whole composition.

It was another seventeenth-century northern European admirer of the Italian Renaissance, the French artist Nicolas Poussin, who first expressly broke with the Albertian ideal of *istoria* on the scale of life that were accessible to all.

When he first settled in Rome, Poussin received private commissions for decorative pictures of battles and mythological scenes. His subsequent attempts at large altarpieces failed to please however, and, during a brief return to Paris, his wall paintings were disliked by the French King.

Having finally attracted patrons among scholarly connoisseurs, and inspired by a small, recently discovered Roman mural, Poussin at last found his *métier*. Imitating the ancient composition by modern

means, he began to paint miniature *istorie* on epic themes: easel pictures roughly the size of Rembrandt's *Belshazzar's Feast*, yet crowded with full-length figures. Seldom has an artist's change of direction been more influential.

Poussin's *Adoration of the Golden Calf* of around 1634 [56] was originally paired with his *Crossing of the Red Sea*, now in Melbourne. Both represent stories from the Old Testament; The Crossing of the Red Sea is related in Exodus 13–15 and The Adoration of the Golden Calf in Exodus 32.

In the wilderness of Sinai, disheartened by the prolonged absence of Moses, the children of Israel asked his brother Aaron, the first High Priest, to make them gods to guide them to the Promised Land. Aaron melted down their gold earrings to cast the Golden Calf, which they began to worship. In his white priest's robes, Aaron stands at the right of the picture, urging them on. Some kneel, many extend their arms imploringly; others, as the text specifies, sing and dance.

Through his antiquarian patrons, Poussin had become acquainted with ancient Greek vases and Roman sarcophagi; he draws on these pagan artefacts

56. Nicolas Poussin, *The Adoration of the Golden Calf*, 1633–4. 153.4 × 211.8 cm.

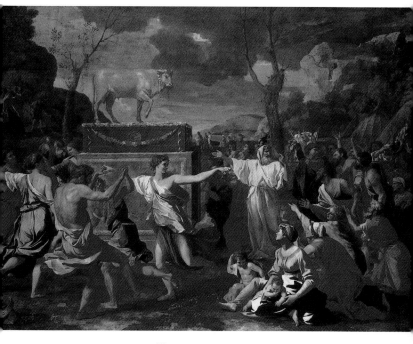

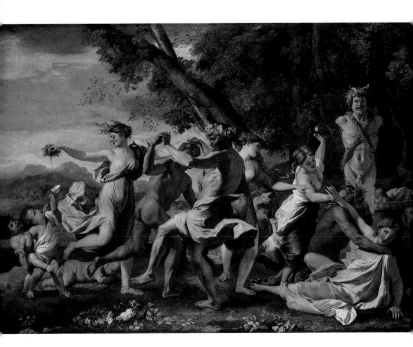

57. Nicolas Poussin, *Bacchanalian Revel before a Term of Pan*, 1632–3. 98 × 142.8 cm.

to represent the biblical Israelites. The idolatrous dancers stomping around the Golden Calf on its Roman altar are a mirror image of a group of nymphs and satyrs Poussin had earlier painted cavorting in a bacchanalian revel [57].

The grandiose Sinaitic setting, however, is quite unlike the bacchic grove. God's wrath is made visible in the glowering storm clouds. In the left background, Moses and Joshua descend Mount Sinai with the tablets of the Ten Commandments. Hearing the singing, and seeing 'the calf and the dancing ... Moses' anger waxed hot, and he cast the tables out of his hands, and brake them beneath the mount' (Exodus 32:19) [58].

*The Crossing of the Red Sea* shows God's miraculous deliverance of the Israelites fleeing slavery in Egypt; *The Adoration of the Golden Calf* their wayward ingratitude. As he mediated the miracle, Moses will now mediate God's vengeance. Calling on those who are 'on the Lord's side', he will order every man to kill his brother, his companion, and his neighbour. 'And there fell of the people that day about three thousand men.' (Exodus 32:26, 28).

This is all no doubt edifying, but compared with Rembrandt's *Belshazzar's Feast* [45], not deeply

involving. We cannot readily identify with the children 58. Detail of 56. of Israel as Poussin paints them, for they seem to have fallen into sin far away and long ago; they are as distanced from us emotionally as they appear remote in space and time.

Most of the apparatus of *istoria* is in evidence in *The Adoration of the Golden Calf* – a high-minded subject, careful delineation of appropriate *affetti*, no unintentional anachronisms of costume or setting. Missing is what Renaissance artists, Alberti and painters such as Rubens and Rembrandt valued most: the ability to 'move the soul' of any, and every, beholder.

59. Jean-Joseph
Taillasson,
*Virgil reading the
Aeneid to
Augustus and
Octavia*, 1787.
147.2 × 166.9 cm.

Poussin impresses by the earnestness of his ambitions, his imagination and intellect. There is poetry in his longing to recapture the appearance of a distant past, and greatness in his very pedantry.

His academic successors, however, imitating the pedantry without the fervour, eventually reduced small-scale *istoria* to bland banality [59].

For those ignorant of ancient literature, or who associate Virgil with stultifying days in the classroom, are alienated by religious images or weary of stale pictorial formulae, there is always modern life. It lends itself uneasily to exemplary History Painting, although from the late eighteenth century many artists made the attempt; among the few to succeed were the Frenchman Jacques-Louis David and the Spaniard Francisco de Goya. In 1867, Edouard Manet, avant-garde Parisian artist and opponent of the regime of Napoleon III, was prompted to emulate them by the tragic fate of the Archduke Ferdinand Maximilian.

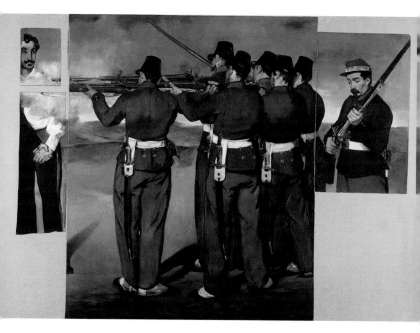

Maximilian had been forcibly installed as Emperor of Mexico by an occupying French army; betrayed by the withdrawal of that army, he was executed, along with two of his generals, Mejía and Miramón, by forces loyal to Mexico's legitimate republican government.

60. Edouard Manet, *The Execution of Maximilian*, about 1867–8. 193 × 284 cm.

Between 1867 and 1869, Manet painted three very large pictures showing Maximilian and his generals facing a firing squad. He left the first picture, now in Boston, unfinished. The second was completed but mutilated by the artist and further damaged after his death. The artist Edgar Degas collected the surviving four fragments and they are now in the National Gallery mounted on a single support [60]. These pieces show General Miramón clasping the Emperor's hand, the firing squad and, on the right, a non-commissioned officer preparing to administer the *coup de grâce*. The French authorities prevented Manet from exhibiting his completed third version, now in Mannheim, which is substantially similar to the second except for the addition of an adobe wall across the background, with sketchy figures crowding over to watch the execution, and a cemetery beyond. The picture shows Maximilian, his head haloed by an upturned Mexican sombrero, standing between the two generals. Only the blurry

spectators suggest emotion, while victims and executioners remain inexpressive.

What made Manet's painting so objectionable to the censors was not only its implied criticism of Napoleon III's disastrous foreign policy (the uniforms of the firing squad were said to resemble those of French troops). It was also the artist's refusal to adopt the traditional rhetoric of Renaissance *istoria*. The evenly lit, workaday impassivity that characterises all three versions itself expresses cold disdain for military heroics and imperial ambitions.

To modern viewers, the fragmentary state of the Gallery's version, with a handclasp the only remaining trace of poor Maximilian [61], seems a poignant comment on the whole affair.

The history of modern History Painting continues fitfully on into the twentieth century. Like Manet in the *The Execution of Maximilian*, modern practitioners have generally been inspired by current events – such as the bombing of the city of Guernica in 1937 during the Spanish Civil War, the theme of one of Pablo Picasso's most famous works, painted for public exhibition in support of the Republican cause.

61. Detail of 60.

# NARRATIVE PAINTINGS WITHOUT TEXTS

Manet and Picasso drew on newspaper reports and photographs; they did not construct their paintings on the basis of any single text – but neither did they invent the stories they depicted. The first artist both to paint text-free stories and to invent his own subjects was the eighteenth-century English printmaker and painter William Hogarth.

Like Poussin, Hogarth had tried and failed to please with monumental History Painting. Trained as an engraver, he conceived the notion of 'modern moral subjects', to be sold both in their original form of small easel paintings and as engravings to be bought on subscription.

There was already a tradition in Europe of large popular prints, mostly combining images with text. Some of these 'broadsheets', like our own comic books, told stories through sequences of separate scenes. Secular ones often resembled the low-life counter-examples of Dutch genre painting (page 24); seventeenth-century Venetian broadsheets, for example, recounted the misfortunes of harlots and rakes.

In the early 1730s, Hogarth himself painted and engraved series of *A Harlot's Progress* and *The Rake's Progress*, transposing the themes to contemporary London, with greater sympathy for the protagonists and indignation at their exploiters.

In 1729, Hogarth had also found success with a painting based on a scene from John Gay's *Beggar's Opera*, which satirised contemporary mores through a tale of highwaymen, jailbirds and their women, set to music adapted from ballads and folk songs. The picture led to commissions for similar paintings of the stage, and small informal group portraits, then called 'conversation pieces', of people in 'good' society.

Out of such ingredients Hogarth fashioned his most ambitious 'modern moral subject', by all accounts his masterpiece, the series of *Marriage A-la-mode, A Variety of Modern Occurrences in High Life*. In six scenes, from the first, entitled *The Marriage Settlement* [62], to the last, the *Suicide of the Countess*

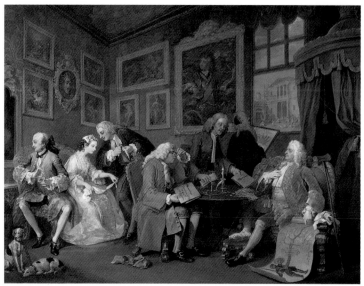

62. William Hogarth, *Marriage A-la-Mode: I, The Marriage Settlement*, before 1743. 69.9 × 90.8 cm.

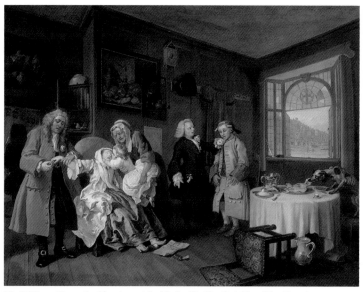

63. William Hogarth, *Marriage A-la-Mode: VI, The Suicide of the Countess*, before 1743. 69.9 × 90.8 cm.

[63], it recounts the story of a loveless marriage, arranged in their own self-interest by the fathers of the hapless bride and groom. It is a melodrama in a comic vein, with many details mocking the things Hogarth especially hated – extravagant greed and cruel avarice [64]; aristocratic pretensions [65] and

64. Detail of 63.

65. Detail of 62.

71

66, 67. Details of Hogarth, *Marriage A-la-Mode: II, Shortly after the Marriage*, before 1743. 69.9 × 90.8 cm.

middle-class vulgarity; classical antiques and voguish Chinoiserie [66]; effete immorality and Puritan self-righteousness [67]. Each scene is shown in a different indoor setting resembling a stage set.

Hogarth elaborated on a theme already well known to contemporaries from plays and poems, to make up a new story that viewers could work out for themselves. He dispensed with inscriptions, the 'broadsheet paraphernalia' of speech balloons and commentary. Even the characters' names are given in documents shown within the images, such as invitations or the broadsheet of an execution. He gave titles to the paintings in the printed *Proposals* announcing their sale, although the engravings are only captioned with the series title and a number. These are enough to 'set the scene' and guide the viewer through the narrative path Hogarth devised. Everything else is achieved by pictorial means alone.

Hogarth had done more than invent a story, or the genres of 'modern moral subject' and 'comic history painting'. He had set narrative painting free of text.

Hogarth's invitation to viewers to work out stories for themselves proved especially influential on nineteenth- and twentieth-century artists.

Most pictures painted before the 1800s are known by titles given to them by curators and art historians. As we have seen, popular prints were commonly captioned and Hogarth titled his paintings of *Marriage A-la-Mode* when announcing their sale. With the advent of public art exhibitions, more artists began to give their works titles in the hope of attracting viewers and potential buyers.

Jean Béraud's painting of about 1885 shows a fashionably dressed *Parisienne* in a drawing room – perhaps not her own, since a warm fur boa encircles her neck [68]. She is hiding her face on the arm of a prosperous sofa. Béraud's title, *After the Misdeed*, tells the rest – and draws attention to the crumpled velvet cushions that bear the imprint of the lady's seducer.

This picture of an anonymous woman, betrayed by her own passions and a male predator, is normally classified as genre painting, but the title blurs the distinction between a typical scene and an individual's story. It introduces the dimension of time – this is a moment *after* the misdeed. The setting, her pose and

68. Jean Béraud, *After the Misdeed*, about 1885–90. 38.1 × 46 cm. On loan to the National Gallery from Tate, London.

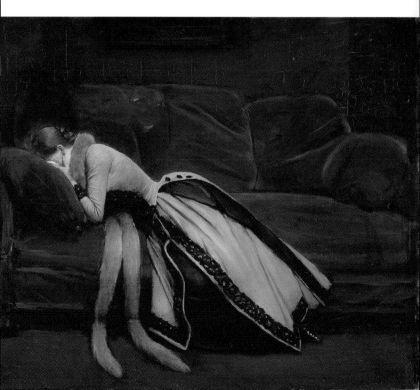

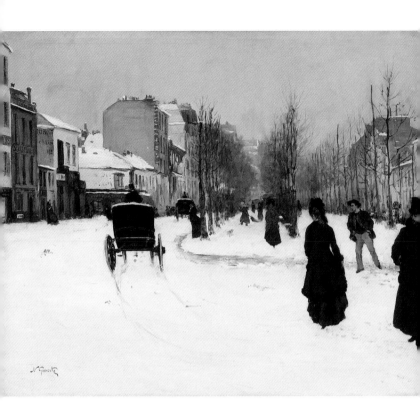

69. Norbert
Goeneutte,
*Boulevard de
Clichy under
Snow*, 1875–6.
60 × 73.3 cm.
On loan to the
National Gallery
from Tate,
London.

her costume indicate the lady is not habitually 'that sort of woman' – this was plainly her first sexual adventure, although, according to contemporary morality, unlikely to be her last.

Like Hogarth's *Marriage A-la-mode* [see 62–67], *After the Misdeed* was not based on a pre-existing text but on a theme familiar to viewers. Béraud, however, did not guide spectators through an entire plot as Hogarth had done. Without betraying the artist's intentions, Béraud's viewers were enabled to become storytellers in their own right. They could even imagine a happy ending – perhaps the lady's redemption through good works, or the love of a good man.

A title suffices to evoke narrative associations from any kind of image. In the winter of 1875–6 Norbert Goeneutte painted *The Boulevard de Clichy under Snow* [69]. Goeneutte's interest in the scene was purely pictorial. An associate of the Impressionists, he wished to capture the fleeting effects of the exceptional weather: the leaden sky under which Paris appears only in monochrome, all white, grey and black; snow sprayed in the air by the turning

wheels of a hansom cab, and melting in the ruts [70].

70. Detail of 69.

Béraud, a friend of Goeneutte, also painted the same view. Deciding to give it additional human, narrative interest he entitled his picture, now lost, *The Return from the Funeral.* How lugubrious the Boulevard de Clichy and its casual passers-by would now have appeared! No longer merely devoid of colour, but desolate. 'Whose funeral was it?' viewers might have wondered, 'Was it a man's? Were his widow and children left destitute? What will happen to them in this vast uncaring city?' Every viewer could imagine a different story, though in this case all would probably be sad.

Given the slightest encouragement, we cannot help but make up stories.

71. Antonello da
Messina,
*Saint Jerome in
his Study*,
about 1456.
45.7 × 36.2 cm.

Paula Rego is one of the most distinguished of a group of contemporary artists who have once again turned to narrative painting. She sometimes illustrates pre-existing texts; more often she invents her own stories. Her main interest, however, is not to impose these on viewers. She exploits the ambiguity of images described by Gombrich (page 30) in order to stimulate spectators' own capacity for spinning tales. In 1990 she was appointed the first Associate Artist at the National Gallery, to make direct use in her own work of the old master paintings in the Collection.

Antonello da Messina's *Saint Jerome in his Study* [71], painted around 1456, inspired Rego's *Time – Past and Present* [72]:

> *Saint Jerome by Antonello is the most magical painting.... I wanted to do this old friend of mine, Keith, as the saint, sitting in the room with all his memories. Some of his memories are taken from pictures in the National Gallery, and some of them are made up.*

Like Pisanello's *Vision of Saint Eustace* [44], Antonello's *Saint Jerome in his Study* is not precisely a narrative painting, yet Rego chooses to reinterpret it as an image of time and memory. Making up her own story, she employs Hogarth's method of expanding it through objects and paintings within the painting. The image of the sailor boy on the wall, and the model boat on top of the cupboard, suggest that Rego's 'Saint Jerome' was once a sailor; the toy hippo may be a memento of distant travels. Other details are more hermetic. Of the little girl drawing – whom we take to be a projection of the artist herself [73] – Rego says:

> *She's doing a secret drawing. I didn't want to put a drawing there, or you could see what she was doing. I didn't want anybody to see it, because it's too secret.*

72. Paula Rego, *Time – Past and Present*, 1990. 183 × 183 cm. Private collection. Courtesy of Marlborough Fine Art, London.

Memories, secrets, legends – invented, like the subject of the painting above the tiles [74], or, like those of Saints Francis and Sebastian around the door, 'taken from pictures in the National Gallery' – infancy, youth and old age, all this is the stuff of stories. Rego says, 'The stories are all important to me, but I use them to create a mood'. Yet she is also quoted as saying, about her borrowings from pictures in the collection: 'the only thing I can do is take a bit here and a bit there and hope that the stories will hold it all together.'

And so they do – not because we know precisely what was in Rego's mind, nor even because they 'create a mood'. They 'hold' Paula Rego's, and all pictures, 'together', because all pictures speak to us as we view them, of our lives, of the passage of time from past to present, of the time we spend dreaming, reading, writing, talking, making love, making or looking at pictures. As Rego also says:

> *That's the wonderful thing about pictures, you can always make up your own story.*

73, 74.
Details of 72.

# FURTHER READING

Christopher Brown,
> *Scenes of Everyday Life – Dutch Genre Painting*
> Ashmolean Museum Publications, Oxford 1999

Judy Egerton,
> *National Gallery Catalogue: The British Paintings*
> National Gallery Company, London 1998

E.H. Gombrich,
> *Art and Illusion: A Study in the Psychology of Pictorial*
> *Representation*
> Phaidon Press, London 1960 (revised paperback 2002)

Alexander Sturgis,
> *Telling Time*
> National Gallery Company, London 2000

Anabel Thomas,
> *An Illustrated Dictionary of Narrative Painting*
> John Murray, London 1993

Colin Wiggins,
> *Paula Rego*
> National Gallery Company, London 1991

PICTURE CREDITS
24. Musée du Louvre. © RMN, Paris. Photo: H. Lewandowski
25. © Copyright The British Museum, London
68. © ADAGP, Paris and DACS, London 2003. Photo:
The National Gallery, London.
72–4. © Paula Rego. Courtesy of Marlborough Fine Art,
London